Being There

Publisher: Master Scholars Press
New York University
School of Medicine

Copyright: Barry M. Goldstein

All rights reserved
Published 2005

Design and typography
Guenet Abraham
Printed by Schmitz Press, Inc.,
Sparks, Maryland

Master Scholars Press
New York University
School of Medicine

Being There

Medical Student Morgue Volunteers Following 9-11

Portraits and
Interviews

September 11, Out my window

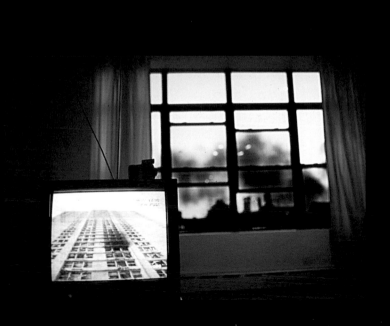

When instructing out-of-town visitors how to find our Manhattan office, I always conclude by telling them that they will recognize the building immediately because it is the ugliest structure in New York City. The line always gets a laugh but unfortunately it is, at least, close to the truth. Nevertheless, in spite of its aesthetic shortcomings, the building met our needs adequately—until 9/11.

Foreword

The Office of Chief Medical Examiner of the City of New York is located on the northeast corner of 30th Street and First Avenue. It stands six stories and has two levels below ground, in total 96,000 sq. ft. The building obviously could not have come close to housing and accommodating the added personnel and supplies needed to accomplish our work in the aftermath of 9/11. Therefore, in order to avoid defeat by the limitations of our physical plant, we made 30th Street a part of our office. The west end of the street was closed to vehicular and pedestrian traffic at First Avenue, and the east end was closed at the service road of the FDR Drive. Tents, trailers, and storage containers lined both sides of 30th Street to house personnel from local, state, and federal agencies and to store large quantities of supplies. I never attempted an accurate count but estimate that 1,000 extra people were on site in the early weeks.

To the untrained observer, 30th Street seemed chaotic. To my colleagues and me, it was the base for an amazing, efficient army whose objective it was to provide timely, technically excellent service with dignity and respect for the

victims and their survivors. Everyone on 30th Street knew his/her job, and no one on that street refused to do anything we asked, whether or not our request was part of their assigned job. Their dedication, stamina, and sense of mission provided inspiration and emotional support for each other. All of us had the sense that we were doing something unique, and we knew that our work was critically important to the public we serve and to our nation.

No group of workers touched my soul more deeply than the medical students who volunteered their time and effort. Many of them had been in medical school less than one month. The largest contingent came from NYU; some came from other schools in New York City. We did not send for them or advertise our need. They just showed up, wanting to help, anxious to participate, and willing to do whatever was necessary.

Excavation of the World Trade Center was finished in May, 2002, at which time 1.7 million tons of debris had been removed. From that debris, recovery teams had culled 19,915 human remains, ranging from intact bodies to small fragments of bone and soft tissue. The remains were transported by truck to our

office where initial screening was done by anthropologists to separate commingled remains and to remove nonhuman remains (there were many restaurants in the twin towers). After anthropological screening, the remains went to one of six identical examination stations, each of which was staffed by a medical examiner, a missing persons detective to take photographs and assist the medical examiner, a police property clerk to remove and voucher personal effects, a member of our DNA laboratory, and a scribe (commonly a medical student) to take notes. The work went on 24/7 from September through December, 16/7 in January and February, and a single, daily 8 hour shift thereafter, with personnel on duty and available 24 hours every day as a contingency.

Since we knew when and where the World Trade Center victims died, why they died, what happened, and who did it, our medicolegal effort quickly focused on the lone remaining issue, identifying the dead. The importance of that effort to bereaved survivors cannot be characterized by words in my vocabulary, and the labels we use, such as "closure" and "finality," in our attempt to capture that importance, are less than inadequate. Although we are unable to define

"I had more than 35 years of a professional life devoted to forensic pathology to prepare me for 9/11. In contrast, the students were confronted by the monstrous consequences of the disaster while still in their professional infancy."

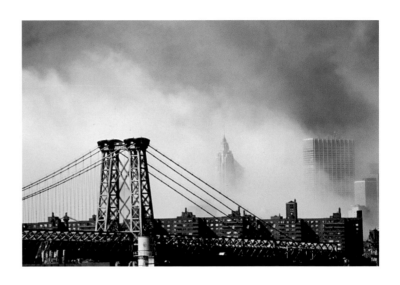

September 11, Williamsburg bridge

and adequately describe the survivors' need for identification of their loved ones, the professional and humanitarian responsibility to meet that need has been a humbling and gratifying pursuit for all of us.

We have identified 1585 (58%) of the 2749 persons reported missing. Only 39 (2.5%) of those identifications were made by personal recognition of the victims; the remaining 97.5% were unrecognizable, in most instances because the victims were fragmented. Many identifications were made by dental examinations and fingerprints, and a modest number were made by unique personal effects. However, DNA comparison was the leading identification technique. In total, 1372 persons were identified by DNA, 528 in combination with other modalities and in 844 as the sole modality. Without DNA we would have identified only 741 (27%) of the fatalities, and our efforts would have concluded in May, 2002, with no hope of future identifications.

By February, 2005, we had exhausted the limits of current DNA technology, so we came to a pause but not a stop. Our commitment to the WTC families is to do whatever it takes for as long as it takes to identify their loved ones. We in-

tend to keep that promise. When new technology provides methods that are more sensitive and better, we will renew our efforts. In effect, we will never stop.

For all of us, the task of dealing with our WTC responsibilities has been arduous, demanding, and daunting. Each of us has had to conquer our own physical, intellectual, and emotional challenges, coping by a variety of mechanisms. In this regard, I always will have special feelings and appreciation for the medical students.

I had more than 35 years of a professional life devoted to forensic pathology to prepare me for 9/11. In contrast, the students were confronted by the monstrous consequences of the disaster while still in their professional infancy. And they did it admirably. They successfully navigated an extremely turbulent experience, and they made invaluable contributions to our efforts. But what was their personal cost and sacrifice? Dr. Barry Goldstein's "Being There" provides insight into the answer to that question. The captivating images and interview excerpts are touching and penetrating revelations. Dr. Goldstein's book gives us a fascinating glimpse into what it meant to be a medical student participant in the forensic investigation of the World Trade Center disaster, the largest mass murder in the history of the United States.

Charles S. Hirsch, M.D., Chief Medical Examiner
of the City of New York, and Professor and
Chairman of Forensic Medicine, and Professor
of Pathology, NYU School of Medicine. 2005

Within 24 hours of the September 11 attacks, a complex of tents and refrigerated trucks appeared on 30th St. and First Ave, adjacent to the Office of Chief Medical Examiner of New York City. This makeshift compound housed the temporary morgues that would receive human remains recovered from Ground Zero.

Introduction

The Office of Chief Medical Examiner (OCME) is attached to the New York University School of Medicine. Medical School dorm rooms directly overlook 30th Street.

In the months following the attacks, approximately twenty NYU medical students volunteered to work alongside the undermanned OCME staff, sorting, cataloguing, and identifying human remains. Some of these students had been in medical school for only a few weeks. All were inexperienced at this work.

I became interested in these students, their experiences, and the unanticipated psychological and emotional consequences of their decisions to volunteer. In May of 2002, nine months after the attacks, I photographed and interviewed sixteen of the OCME volunteers. For the portrait sessions, I asked each subject to bring something that had helped them survive their time in the morgues. For the interviews, I asked the students to describe what they did, what they would remember, how they were changed by the experience, and, finally, to describe the significance of their props.

The results were sometimes surprising, and always moving...

I lived in New York City from July 2001 through June 2002. I was on leave from the University of Rochester, having been appointed as Visiting Professor in Humanism in Medicine at the New York University Medical School. My stay was sponsored by the Master Scholars Program, a unique medical humanities program involving a large number of the NYU Medical faculty. I planned to teach medical students about the history of photography in medicine, the ways in which photography had been used to portray doctors and patients, and how these representations had changed over time. I also planned to undertake a project photographing doctors and their patients at NYU and Bellevue. My first "official" day was September 11, 2001.

I saw and photographed the attacks, and photographed in and around Manhattan over the next week. Later, I was asked to document the "memorial wall" of photographs of the missing victims that had grown around Bellevue. This work appeared in the NYU Master Scholars Program book "Dialogues" and was subsequently reprinted and exhibited in several venues. Working on this material was emotionally exhausting, and over the next six months, I returned to my original project and teaching plans.

It is something of a cliché to say that the 9-11 attacks provoked a sea change in American life. Virtually every aspect of our society has been affected, and we have grown accustomed to hearing of the events of that day through the narratives of the media, and those of government, law enforcement, military, and service personnel. However, many who witnessed these attacks and their aftermath were profoundly affected in ways that can still remain difficult to describe. Thus, while the City had returned to "normal" by the spring of 2002, it was clear that the memories of 9-11 were still very much alive among my students and colleagues at NYU.

During the winter, I'd heard about a group of NYU medical students who had volunteered to assist the staff of the Office of Chief Medical Examiner (OCME) in the identification of human remains recovered at Ground Zero. On the day after the attacks, a large complex of tents and refrigerated trailers took up residence on 30th St. and First Ave. and was zealously guarded by law enforcement personnel. All remains from Ground Zero were brought to this site, which served as a daily, unavoidable reminder of the events of the 11th. I found it astonishing that medical students, most of whom were still in their first year, had been allowed entry into this world.

The role of the OCME is described on its web site as follows:

"The Office of Chief Medical Examiner investigates cases of persons who die within New York City from criminal violence; by casualty or by suicide; suddenly, when in apparent good health; when unattended by a physician; in a correctional facility; or in any suspicious or unusual manner…."

Chief Medical Examiner Charles S. Hirsch organized a massive effort, involving both the humanitarian task of identifying remains, as well as the forensic task of gathering evidence for a criminal investigation. This required the coordination of physicians, government officials, and local and national law enforcement personnel. A consummate professional, by all accounts he did a superb job. However, the OCME staff was overwhelmed, particularly during the months immediately following the 11th. Coupled with this was the desire on the part of the medical students to help in any capacity. This need to be of service was to be echoed over and over in interviews. After a great deal of discussion between the students, the Dean of Students, Dr. Mariano Rey, and Dr. Hirsch, it was agreed that medical students could serve primarily as "scribes," taking notes dictated by the forensic pathologists and law enforce-

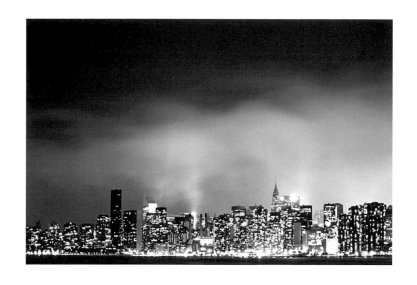

September 13, Manhattan skyline

ment personnel. This decision was to have a profound impact on some of these students.

When I first heard about the student volunteers, I was skeptical. Students of this age and lack of experience could have little idea of what they would be exposing themselves to, and could offer little in the way of skill or expertise to the forensic effort. However, as I spoke further with the students who'd organized the effort, I began to modify my opinions, if not entirely change them. Counseling services had been set up, and students' responsibilities were clearly defined. Dr. Hirsch was very supportive of the idea and felt that his staff truly needed the help of individuals who at least understood anatomical nomenclature. As became apparent during the interviews, we were all, to some degree, correct in our judgments.

I was interested in the motivations of these students, and how they had responded when faced with the almost unimaginably brutal consequences of the 9-11 attacks. I also felt that a highly personalized account would provide a view of the tragedy, not from the perspective of global events, but through that of individuals. It would focus on the efforts of a group of mostly young, inexperienced students who found themselves in an extraordinary situation.

Of course, we have been subjecting young people to worse trials for millennia by sending them to war. In this case though, the war had, for some brief moments, come to those who were neither trained for, nor expected it. In this regard, the students were no different from the many hundreds of thousands of New Yorkers who were personally touched by the attacks. Their stories might then serve as a distillation of the experiences and fears of the rest of us.

The students I initially approached about the project were wary. Many felt that what they had done was not exceptional, and were hesitant to cast themselves in any way as "heroic." Further, some of the students felt that they had, for one reason or another, let themselves and/or the victims down, and were reluctant to gain attention from what they saw as their failures. In each case, my argument was the same; the purpose of this project was to document individuals. There was no agenda. What each student chose to relate about their motivations, experiences, and memories was up to them.

I began photographing and interviewing the students approximately nine months after the attacks. The timing, though not deliberate, turned out to be fortuitous. Students worked in the morgues for anywhere from weeks to months

after the attacks. By the spring of 2002, the time seemed right to begin to deal with memories that had, in many cases, been deliberately buried under the normal, heavy academic workload of first and second year medical students. Interviews lasted at least an hour, were sometimes longer, and were often cathartic. Once the students became comfortable, they generally needed little prompting to tell their stories.

The interview excerpts vary in length from a few sentences to many pages. The reasons for this do not reflect my subjects' level of involvement at OCME or their commitment to the project, but simply my own editorial choices. That said, I have made every effort to remain sensitive to victims' families, while still conveying something of the reality experienced by these men and women. It should be noted that several of the volunteers chose not to participate in the project. Their wishes have been respected.

Portrait sessions were held in a makeshift studio set up in one of the medical school teaching labs. Students were asked to wear the clothes they wore in the morgues, and to bring something that had helped them deal with the stress,

fear, and depression associated with their work. The nature and variety of these "props" were touching—companions, both human and animal, real or stuffed; images; articles of clothing—all served their roles in providing some combination of motivation and comfort. As they sat for their portraits, the students were simply asked to think about their time in the morgues.

I've worked with many portrait subjects. For reasons I still find unclear, these students were surprisingly adept at absenting themselves from the entire process of picture taking. As a result, the masks that we generally put on for the world when faced with a camera were absent.

They bared themselves. All I really had to do was release the shutter.

Almost four years have passed since 9-11. The world continues to experience new tragedies, both natural and man-made. Some have resulted from the events described here. Each generates its own stories and images, which are rendered into "history" with the passage of time. It is hoped that this particular work will preserve at least a small part of a traumatic event, and thereby honor the memories of all involved.

Barry M. Goldstein 2005

Portraits and Interviews

Elspeth Kinnucan

age 24,
with pictures
of her two sisters,
Allison (left) and
Challis (right)

"It was clear that, being in medical school only a few weeks, there was not a lot that I could do...But I wanted to do something. I'd never touched or been around a dead body before coming to medical school...These images will stay with me a long time—the smell; how incredibly violent this was. In anatomy, the cadavers are intact...

It didn't bother me 'till Christmas...I woke up shaking. I was having nightmares about planes hitting the ground or a building-people are running, falling, dying—and I couldn't do anything for them.

Challis stayed with me in my room when I'd wake up and have the nightmares.

I pretty much grew up a Quaker. It's a very pacifist view. I have a few guiding ideas about how to get through life. They're being really challenged by the people around me now. Allison helped me with this. She did a silent peace vigil for two months.

The U.S. pushes a lot of people's buttons in other parts of the world. I don't think we can avoid it. It's probably inevitable that there will be more acts of terrorism.

I was happy to have my family around me at Christmas. I'd completely isolated myself."

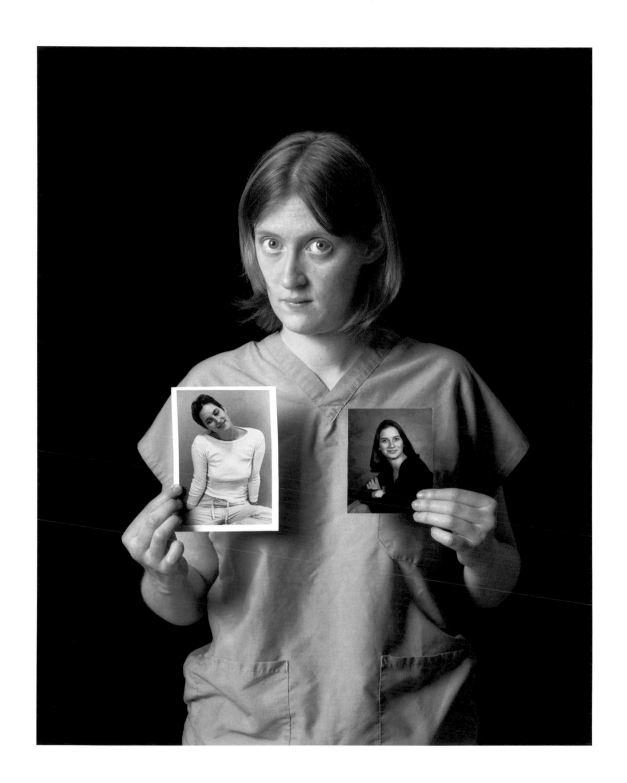

Michelle Mendoza

age 22,
with Patrick

Michelle was born in the Philippines, and came to the US when she was seven. She grew up in Texas and New York City.

How did you come to work at OCME?

Well, basically what happened was that on September 11th, after everything had happened in the morning, everyone was, you know, kind of frantic as to where we could go to help. It was funny because it seemed like the less medical education we had the more we wanted to help. The older students were like, "Well we don't know how to do anything so there's no point in us trying to go to help."

I changed into my scrubs and went down to the ME's office. I didn't really feel much like sitting around...so I met up with [a pathologist] and she just had me working as a scribe with an identification team at a table. So pretty much from about four o'clock in the afternoon till I think it was about one thirty or two o'clock the next morning, I was just standing there, just describing everything that the pathologist was saying about either the body part or the actual body, if we had one. You know, to try and identify it or him or her...and then I was kind of bouncing around between helping to collect DNA and then becoming the pathologist's scribe...I guess that was pretty much it for as long as I worked there, which was, I would say, about all of first semester after it happened.

I would go in any time I had any free time. You know, it was actually getting almost obsessive, because I wasn't really spending as much time with any of my classmates or any of the friends I had. I was just like, "I have to go to the ME's office." I was like, "Okay this is just a job. I'm doing what I can to help and that's it." There wasn't any question of "Well, how am I going to be able to handle this." I was just going, going. I wasn't really taking the time out to feel anything...I was slowly getting consumed by it...

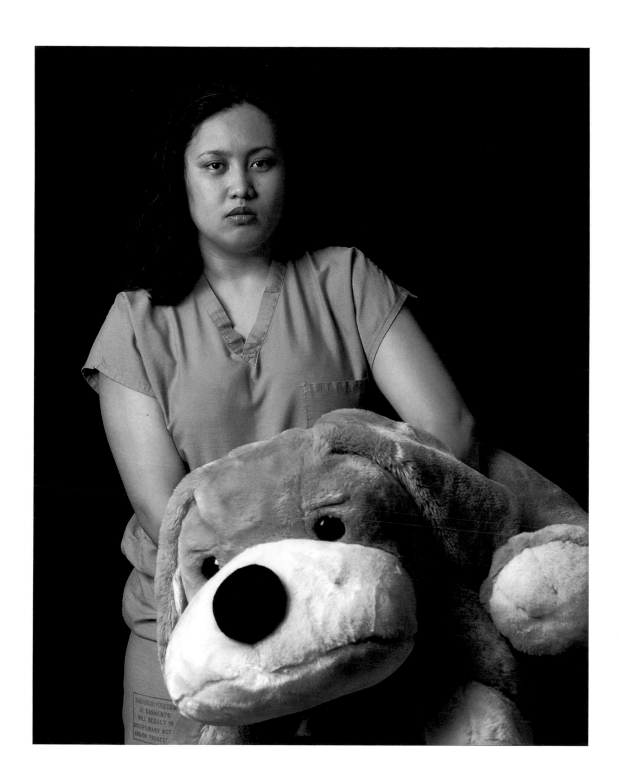

Michelle Mendoza

(continued)

What do you remember the most about your experience?

The first three people that we identified with a 100% certainty, their names I'll never forget.

You know, when [the pathologist] brought me down to the docking bay where they had set up all the tables, the first thing I saw was a leg, and I thought "Okay, well, that's not any different from what I saw in anatomy lab except it's kind of separated from the body, and I won't know what the rest of the body looks like," but then a couple of hours later the table we were at had a firefighter on it, and it was very obvious who he was…then there was his name and then I switched tables to relieve somebody and there was that guy's name and…

I mean there have been a lot of names since then, and it's just those three, those very first three that sometimes I'll just, I don't know, sitting, studying, I mean I could be so far away from it and they'll kind of just pop into my head. Kind of like how a grocery list would, or remembering an appointment, [they] would kind of just pop into your head.

And you know, I was telling my boyfriend this, that I just wanted it to kind of stop. I didn't want the names to pop into my head anymore. I didn't want see the names and then see the bodies and see all the little personal items that we had retrieved from the bodies. You know, I just didn't want to see it anymore. I didn't want to think about it anymore. I didn't want to get upset over it anymore, so we were just sitting there trying to figure out what I could do, and I kind of just got up and got a piece of paper and I wrote the names down and took a match and just put it on a little dish and lit the paper and just let it burn.

…I feel like it's, I feel like it's gotten better since then. You know, just even symbolically, just to get rid of it. Because my thing is that, I don't want to forget it, because I don't want to…'cause it really has become a big part of me, and I feel like I would lose part of myself if I forget it.

"I wrote the names down and took a match and ...lit the paper and just let it burn."

But then again, I don't want it to overwhelm me either, so there's kind of that balancing act between the two, and sometimes I feel like I'm on the overwhelmed side, and I feel like sometimes I'm on the forgetting side. But I think it probably will take a few years before I can really, you know, feel like I'm okay about it.

Tell me about your first prop—Patrick.

...the first night I came back from working at the ME's office, I was really afraid to take a shower. I was really afraid to get in the shower and have to...to close my eyes while the water was running over me because...I kind of feel like if I keep my eyes open then I see just what's there and I don't see what's in my head. But when you close your eyes then you're left with this blank canvas for a second, and then you start seeing things...

And I was really afraid, but I needed to take a shower because I was working at the morgue for something like nine hours and, you know, it smelled. I smelled really badly and I felt like it really permeated deep into my skin, so for about 15 minutes I was just under the shower with my eyes open and not really letting the water run over me like I needed it to.

And then finally I just closed my eyes and, you know, what I was afraid of happening happened. I started seeing the faces and I started seeing the different parts and that's when I started crying. I think I must have been in that shower for about an hour, because it took me that long to feel like I was, you know, clean, and just trying to get a grip on myself because I was just sobbing.

Then I went back to my room. I had lived on the first floor of Reuben so I had kind of this loft bed, [but] I had a little futon [on the floor] that was really uncomfortable to lie down on, but that's where Patrick sat and I just, I felt like I didn't have the energy to climb up to my bed, which is like 13 feet up in the air.

Michelle Mendoza
(continued)

So I just laid down on the [floor] and put Patrick over me, 'cause it was the closest thing to a hug that I could really get at four in the morning.

That's kind of how I slept for a couple of weeks–just not wanting to get up on the bed, 'cause I could see out of my window if I'm in bed, but if I'm on [the floor], then lots of things are blocking the window…so I just kind of stayed down there and…he was the only company I had for a while. The only company I was able to really spend any time with alone…The only 'person' I could stand being with.

I mean, it's not easy living on 30th Street. All we saw out the window were the white trucks and the big tent outside…

How were you changed by the experience?

I don't know for sure, but I think that I definitely became a lot more fragile. Being strong has always been something that was attributed to me by my mom, friends, just different family members–they've always said that I was really strong and just really able to handle a lot of things that most normal people wouldn't be able to handle. And, you know, I don't know about that anymore.

And I think about sometimes whether or not it was worth it to spend all that time and to have been that consumed by the job when definitely someone else could have done it–when there were more than enough people to fill my place. I was totally expendable…

I just felt that…well, something's has got to happen at some point in my lifetime that is going to be the defining moment of my life. Like how the Great Depression was for my grandparents and the Vietnam War was for my dad.

So I had always thought it was going to be on the other side of the world when it happened. I didn't think I would be a few blocks from where it happened…

"Every day is just trying to recapture who I was. And try to be me again."

I mean, there are times when I think, "Well, I was part of history," or...I don't know. I mean, again, is that worth it?

I have moments of kind of some semblance of my old self. Just–every day is just trying to recapture who I was. And, you know, try to be me again.

Tell me about your second "prop"—your boyfriend Craig.

I will say that in the past couple of months a lot of things have come to a head. A lot of stresses have been placed on my shoulders, which, compared to what I was doing last semester, seem like totally mundane and completely survivable and completely manageable.

Except that I feel like...with each thing that has come along in the past couple of months, I felt closer and closer to kind of breaking...Lately I've just been very depressed. Constantly just crying and being withdrawn and my poor boyfriend is just kind of sitting there wondering what is going on and what he can do, 'cause it doesn't seem like anything he does helps.

You know, being there doesn't help, but not being there doesn't help either, and he's kind of caught in this netherworld...I was just so sad and the only thing I could think of was like, "Oh God, I just wish I didn't have to feel this way..."

And it's just–it's hard on him, because the reason why I paste on that smile is 'cause I don't want to have to deal with questions. I don't want to have to deal with "Well what's wrong?" and "Are you okay?" or "Is there anything I can do to help?" And so that means that by the time I get home, not only am I exhausted from the effort of trying to be happy, but exhausted from actually being sad.

And, lo and behold, who gets the brunt of that exhaustion and sadness is Craig. So he's probably not doing well now. I would say he's probably doing about as bad as me right now...

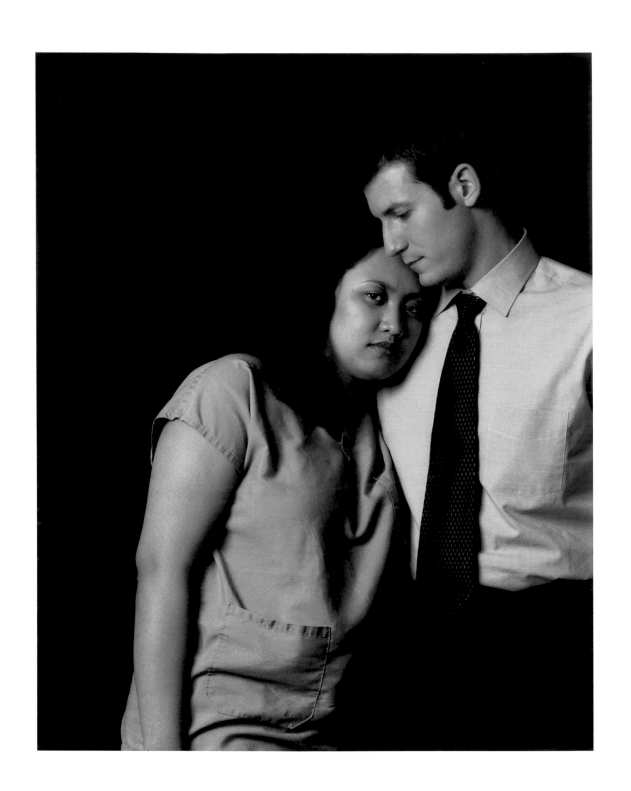

Michelle Mendoza

(continued)

with boyfriend Craig

I feel like, I feel bad that he feels obligated to stick around...because there's nothing to be done right now. I just have to figure out a way to get out of this funk that I'm in. I don't know if him staying is necessarily helping. Then again, I don't know if being alone would necessarily be good either.

You feel like—even though I'm not exactly back to where I was, without him I wouldn't have come this far. So even though he didn't help me during the actual event, he kind of, yes, he definitely helped me after. I mean I honestly wouldn't know where I'd be without him 'cause he's just got a heart of gold and a lot of patience...a lot of patience. You know, I thought that parents were the only ones who were allowed to put up with you this long, 'cause it's their fault you were brought in this world. But he's, yes, he's definitely been there for me. And just continues to be there for me.

[Michelle and Craig stopped dating in 2003]

Doron Stember

age 27,
with picture
of former view
outside his family
apartment

"My great aunt Sylvia was like my grandmother. She lived in this apartment on the Lower East Side my whole life. I've visited there since I was little…She worked on the 80th floor of one of the twin towers. We'd go out on the balcony, which had a beautiful view of the towers, and count the floors. So, growing up, I always associated her with this view. Then she passed away my senior year of college. I graduated and went to live there, in the apartment…

I thought about her whenever I was on the balcony. One day I picked up my camera and took this picture.

On September 11th, we were in class. We went outside and heard that both towers had collapsed. They told all med students to put on scrubs and go to the Bellevue ER, but it was mobbed with doctors. We waited all day, but no one came in. We were frustrated.

At the end of the day I went back home and was afraid to go out on the balcony. I finally went out–that's when I got really upset. It really hurt me–the association with my aunt.

I'm so glad I have that picture of what I saw with her for 27 years…"

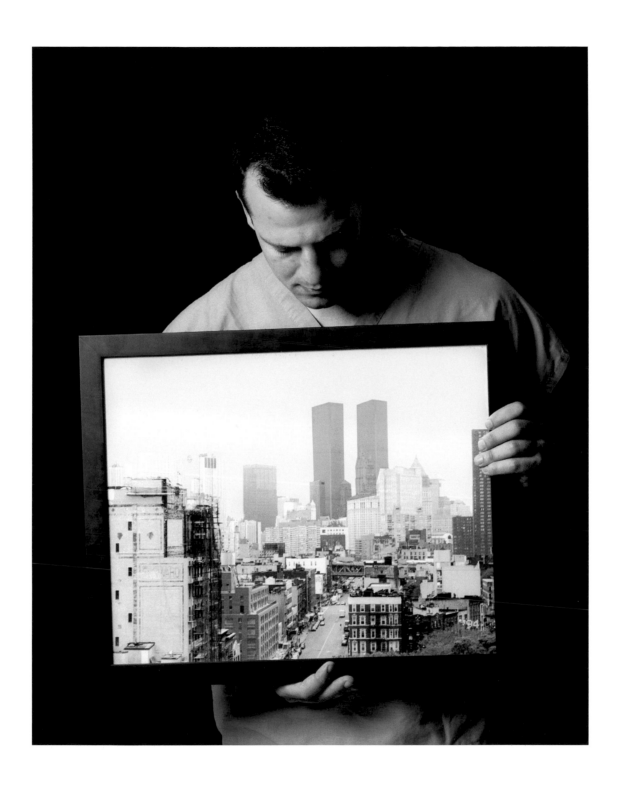

Wasif Ali

age 24,
with EMT badge

Wasif is a practicing Muslim. He's worked as an EMT since high school. In the weeks after 9-11, he worked as an EMT and in the morgue.

"After 9-11, I would wear my EMT shirt so I wouldn't be harassed...I don't want to have to prove myself. Just because I'm Muslim doesn't mean I'm 'other.' We could talk about this a long time, how people focus on the enemy as a uniting point... I had a goatee before 9-11, but I got rid of it a week later–sort of less threatening...I thought I'd lay low I guess.

[Being Muslim] was something I had to deal with after 9-11. We're not a perfect country."

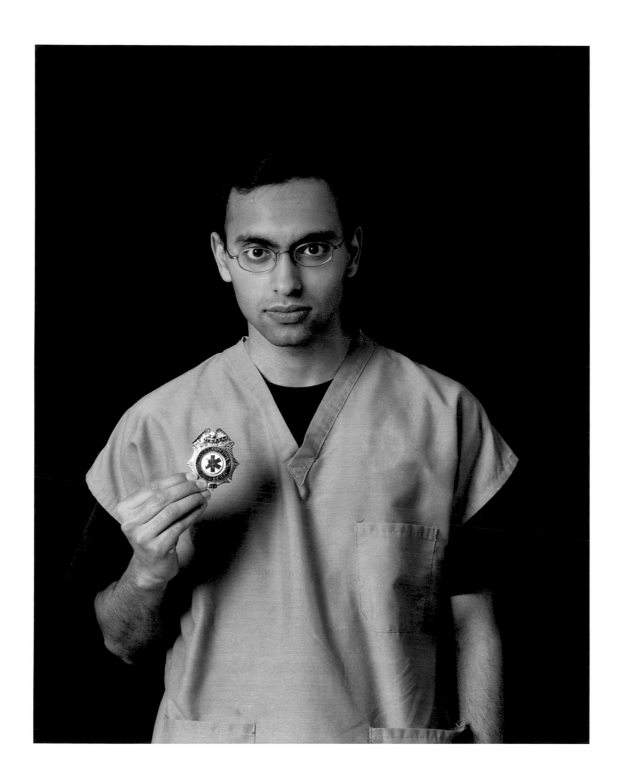

William Ching

age 29,
with Magda

How long did you work in the morgue?

I did most of it after Flight 587–about three weeks after
9-11. I worked there several weeks in 4-to-8 hour shifts.

What did you do?

Anything they wanted–processing DNA samples, handling re-
mains.

How was it different from what you expected?

I'd gone through many autopsies, but never anything like this.
Law enforcement was involved. Also, the condition of the re-
mains was different. In an autopsy, the remains are intact. You also
see, smell, and touch things that you don't ever want anyone to
see or touch–ever.

What will you remember, for better or worse?

That's a tough one.

I think there's a reason we went into medicine in the first place,
which was to heal. One thing that you learn throughout training
is that you have to accept death as an inevitable consequence of
life. And whether it comes expectedly or unexpectedly; in nice
ways or not so nice ways; it's there.

And that no matter how huge the extent of a disaster, there's a
mission that's still there:

For the living you try to provide hope, and to find a way to
bring them back to wellness; and for those who have passed on
you try to give hope and heal those who remain behind,
whether it's by returning their loved ones to them, or having
them know finally what happened.

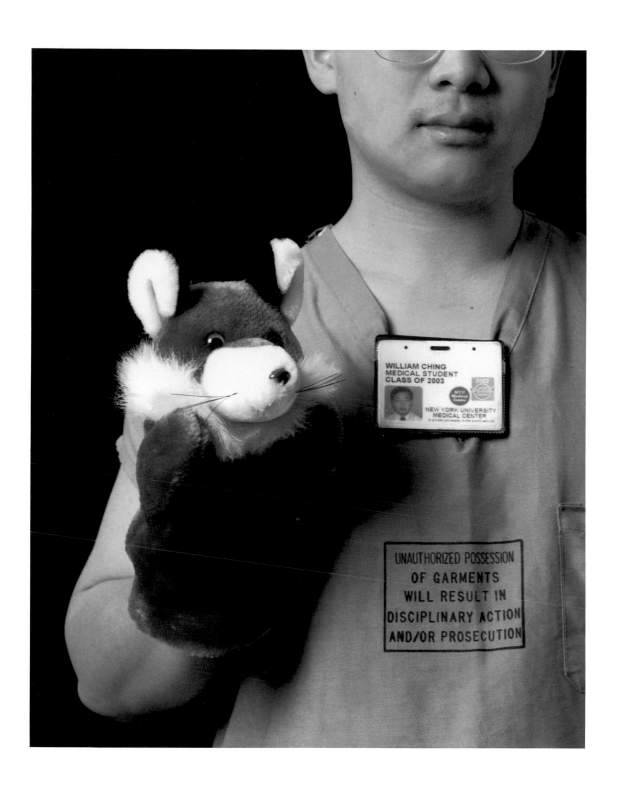

William Ching

(continued)

And it's not as different a mission, those two, as it may sound... whereas in the hospital you stitch up something, or do a surgery, and say, OK that's fixed, in the ME's office there's no such luxury, but [rather] yes, we've made an identification, we know who this person is, where they were, and now we can notify the family; that mission is one and the same. I think that kind of thinking gave strength to everyone. The hours were long.

What you see...I still have nightmares about it.

Tell me about your prop—the puppet.

I'm a big believer in toys, and a sense of humor. The puppet's name is Magda, named after a friend of mine from Poland named Magdalene. The puppet looks just like her. (She's almost preternaturally peppy.)

I could channel silliness through Magda.

For better or worse, I'm known as a bit of a clown, and I had friends who needed cheering up. We all got a good laugh out of it—which was a rare commodity.

How were you changed by your experiences?

A friend and colleague of mine was on the [Pentagon] airplane. I was supposed to talk to him earlier in the week, and didn't get to it. His name was at the top of the casualty list. It really makes you think that it's never too early or late to tell people how you feel about them. He was a friend and a role model.

The complete randomness of it...

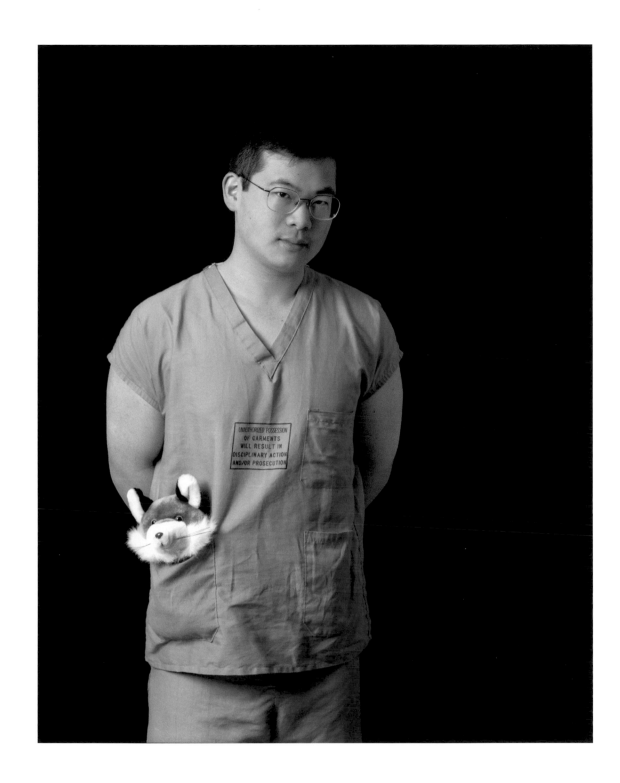

Ania Jankowska

age 22,
with NYPD
Missing Persons
Squad jacket

"At some point I realized we were looking for persons, not looking through bodies...

My first two times [at OCME] I did triage, which is basically [to] open up the bags and sort through to see if it was human remains or not...and progressively the [remains] that actually arrived together were smaller and smaller...

There were so many people that still weren't found...

...I don't think I'll ever look at death the same way again because it was such a huge presence during an entire year of my life."

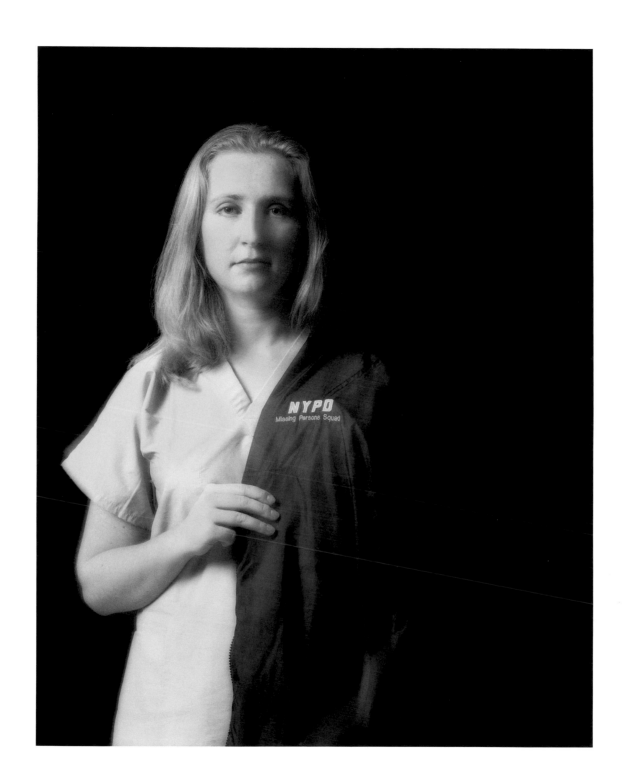

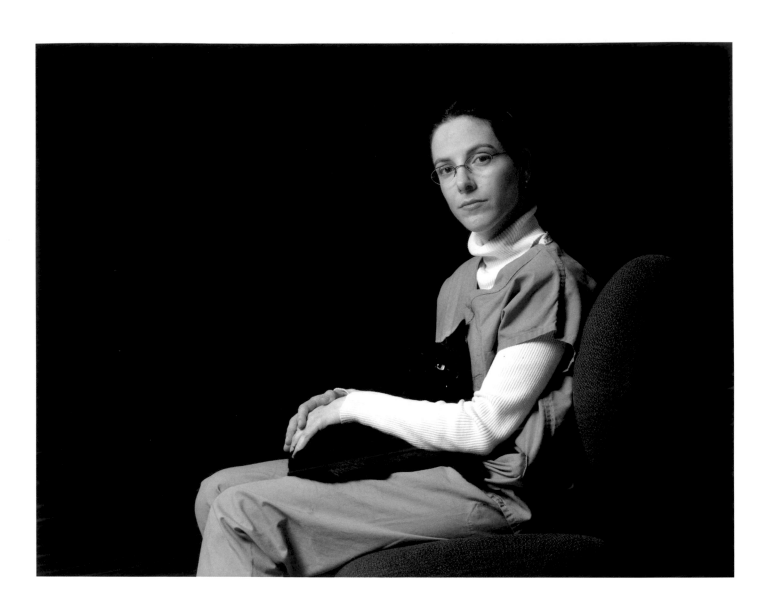

Marissa Kaminsky

with cat Shane

"I'm infatuated with my cat. I take it for granted that he'll always be there.

When I'd come home from the morgue, he'd smell everything, so I'd go in the bathroom and take off my clothes and wash my hands...

I never felt that I needed more than my cat. I think about all those people who lost loved ones. My cat is always there.

I think about coming home to an empty house. I feel like I need someone there a lot more now."

Elizabeth Hackett

age 24,
with boyfriend
Joe

Three days after the attacks, Elizabeth learned that the father of her childhood friend was missing.

"And I realized that she wasn't accepting the fact that he was probably dead and she was asking me for information all the time and I knew the situation down here by about the middle of the second week. Pretty much everybody at the medical center realized that there were not going to be any more survivors found...there weren't people sitting in hospitals with amnesia that were suddenly going to turn up...

I think I did feel guilty about not being able to help her and I felt like...I don't know, working there would somehow make me feel better about that.

[But] I think in a sense it made it worse because I found that I wasn't able to continue with it...the images of the things that I saw there, you know, kept recurring in my dreams...And I realized that that was going to become a problem if I stayed there.

Joe helped me with that a lot...he told me, 'Look, you know you're crazy for feeling bad. You don't have to go and you're not a weak person and this is a perfectly normal thing to do to say you don't want to go back there...It's okay if you don't go back there,' and he made me feel more, more normal in doing that and like it was okay to stop working there.

Knowing of somebody that I knew growing up who died and also the feelings of helplessness were part of what made it so difficult. That I felt that I wasn't able to contribute much positively to the situation...so just the feeling of overall not, not being a useful person..."

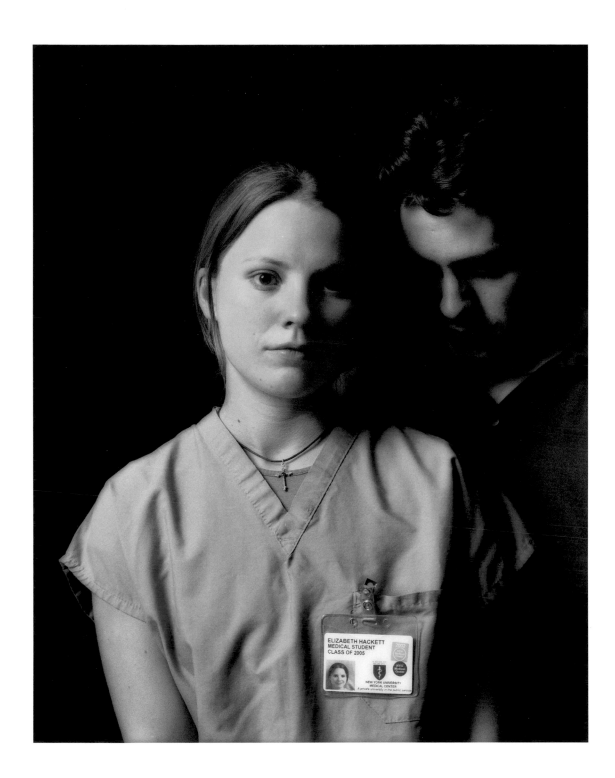

Denitza Blagev

Denitza lived in Bulgaria until age 11, where she started playing tennis.

age 24,
with tennis racket

"I'd signed up for a tennis tournament in Central Park a month before 9-11. It was held the following Saturday and I decided to play. It felt good to get away from the posters, the smell, people crying. All I had to worry about was someone's backhand.

In some ways, [working in the morgue] is like tennis. You practice 6 hours a day, 6 days a week and you don't ask, 'Why am I doing this ?' You just do it."

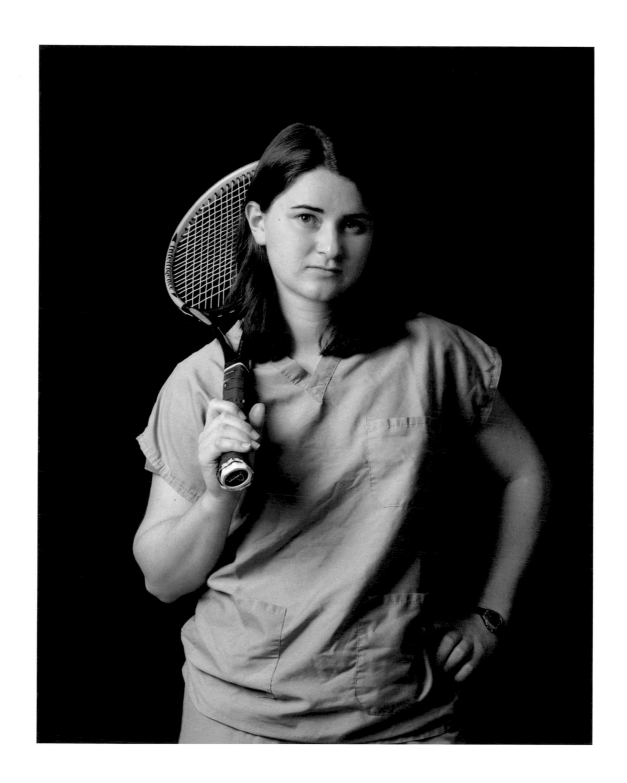

Arthur Boykin

age 26,
with the Book of
Common Prayer

When did you work at OCME, and for how long?

I started volunteer work in the first week or two after 9-11.
I worked about a week and a half.

Why did you volunteer?

Right after the attack, I went to the Bellevue ER, but there were
no patients. By 10 PM we were sent home and told to come
back in the morning, when it was expected that they would have
found survivors.

As I walked home, I passed the ME's building and thought, 'This
is where they will really need help.' I had hope, but knew that
even if we had survivors, there'd be a lot more dead—we'd have a
lot of bodies to deal with.

Describe what you did.

We worked in groups of three in shifts around the clock, tran-
scribing the ME's record, filling out paperwork and cataloging
items that we found. [In other words,] a member of the ME's staff
would do the postmortum, and we'd take notes, along with the
police, who did the same for their records.

How was it different from what you expected?

It was a lot dirtier than I expected. Everything was gray—pulver-
ized with gray ash, and wet; wet from the firefighters' spray.
Everything—clothes, remains, everything. This stuff had been
buried under tons of rubble.

What will stay with you the most?

The smell. You open the bag and it hits you. I can be 90 years
old, delirious in the ICU with the other old timers, and I will
still remember the smell...And something else:

Everything was gray, regardless of the race of the victim. BUT,
when you found a person with their wallet, the police would take
everything out to photograph, and you'd see these bright pristine
colored pieces of plastic. The contrast was so stark.

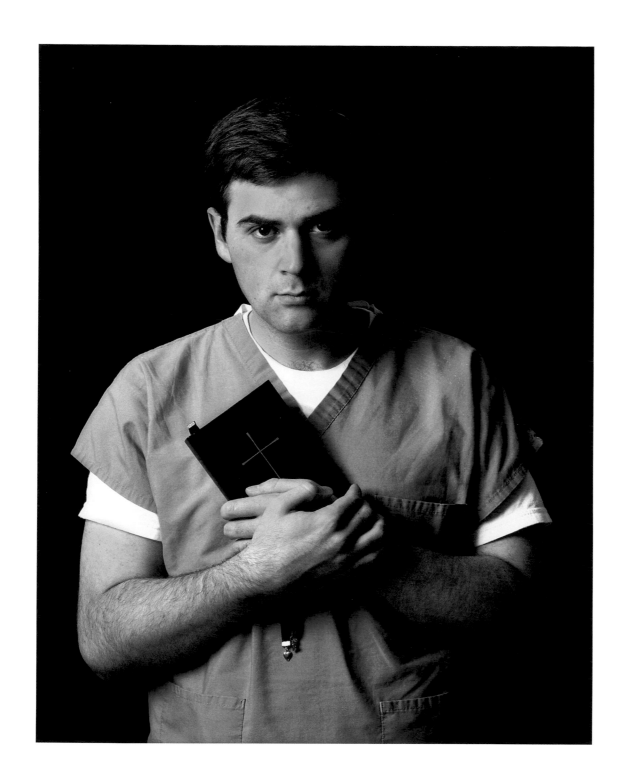

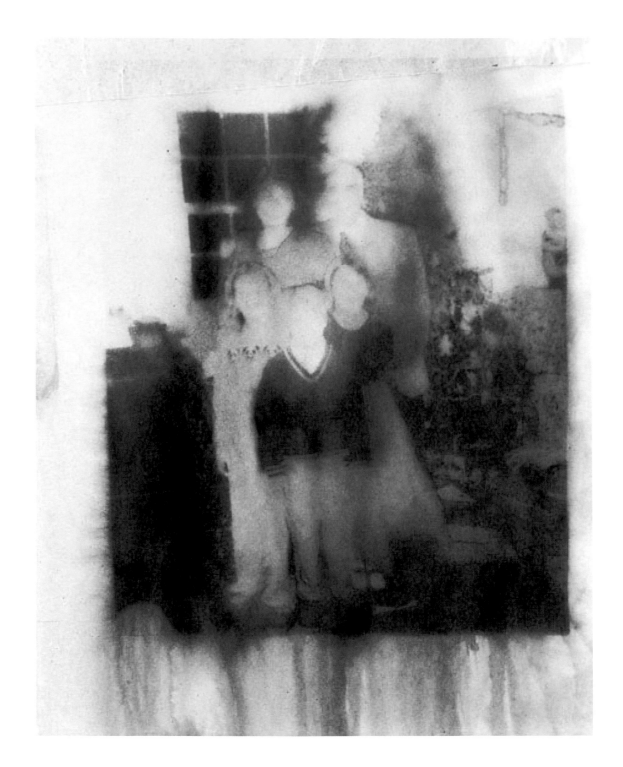

October 1, Missing person poster, Bellevue Hospital

Arthur Boykin
(continued)

That's also when you'd see who these people really were—what they looked like.

I'd go outside and look at the wall [the Bellevue wall photos]. You'd find people not unlike yourself. I mean, how many 20-something people worked in the WTC?

Did you ever find someone on the wall that you'd helped to identify?
No. I did look.

Describe the significance of your prop—this is a Bible?
My prop is actually not my Bible. It's the Book of Common Prayer (I thought it would be more photogenic). I felt more religious during this period. I haven't been much of a church-going person, but the book represented the fact that God and faith helped get me through this.

There has to be a really good reason for me to pray. I prayed more than I usually do. I prayed more...

I've never been called to question my faith. Christianity and the Episcopal faith also represent a contact with my family. They got me through this too. I would talk to my mother every day. They were supportive, and it was very hard for them. They wanted me out of the city—'Come home,' (they'd say) 'get the hell out of there.' But they also understood.

How do they feel now about what you did?
They told me they were proud of me.

You know the real reason I did this...

On 9-11, there was such a feeling of helplessness. The best part of this experience...we were doing something, we were contributing. The most difficult thing about the events of 9-11 for many people was that they could do nothing (that's why you had these blocks-long lines of people waiting to give blood). I was glad I was in a situation where I could do something.

Crissy Franchetti

age 24,
with Dr. Bear

"I don't think there are many times in my life when I thought, 'I want my mother.'

I'm trying not to always focus on the tragedy of 9-11. 'Dr. Bear' represents my future—why I'm working so hard—so that I will actually be able to help somebody. What am I doing to help anybody [now] ? Nothing. 'Dr. Bear' represents my light at the end of the tunnel.

I didn't expect to be studying all the time...[but it's] a diversion from thinking of death..."

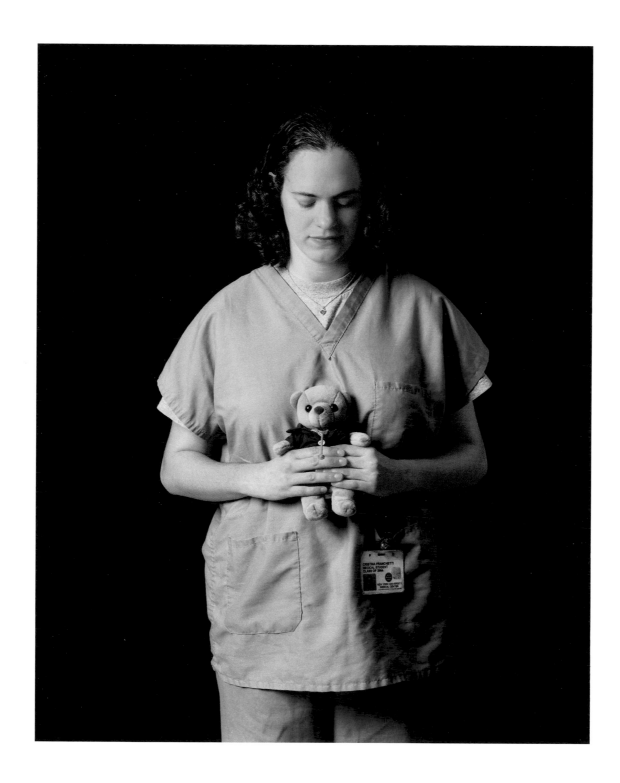

Michael Starsiak

age 33,
with journal

"The area where they actually expanded the morgue was flowing out into the street underneath a tent that had been set up by the garage...Now this was expanded outside with tables, and sort of like a mobile morgue.

A few people had gone over [there]...who had felt like they might have had some experience in anthropology and other special skills, besides just being a medical student.

I had a brief conversation with [a pathologist], and sort of mentioned that I had experience with X-rays and had a license, and he stopped. He called and brought me down into the area where they're doing dental X-rays, and I didn't mention anything about dental, but he thought, 'Well that's close enough' and yelled down the hallway asking if they needed anybody, and they overwhelmingly responded 'yes.'

So I found myself down there...doing dental X-rays in a very chaotic environment, with a mobile army X-ray unit in a tiny room with very little regard for radiation protection or anything like that, and I had no idea what I was doing, but I learned quickly. And we did pretty good work.

I couldn't have dreamt of the extremity of it...you've seen movies before where they do some...they're doing some autopsy, whatever...But there are other senses involved, smell, touch, hearing, and maybe even taste.

I mean there were things that I did [that] I didn't think I would have to do...they would say to me like, 'Well, you'll have to go through this and find what you can,' and I thought, 'Are these people serious?'

It's amazing to see what could happen to a human. It goes beyond the imagination.

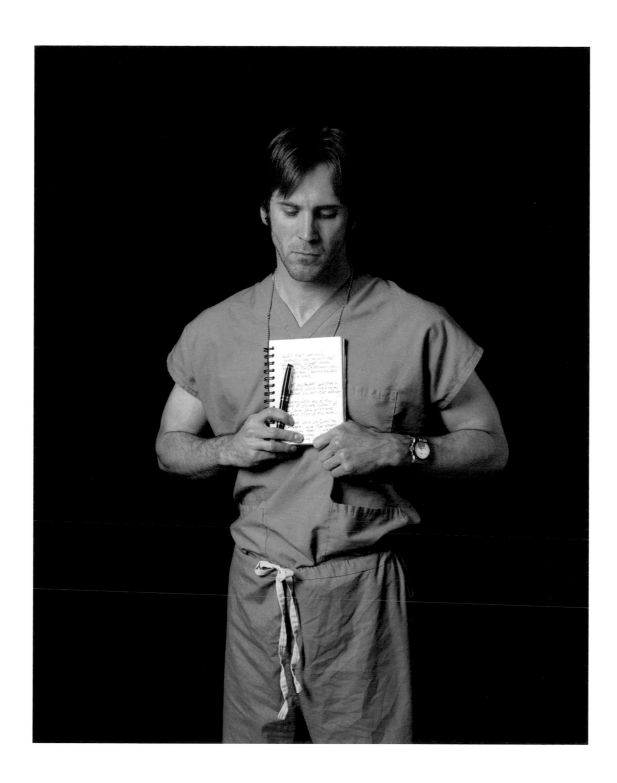

Michael Starsiak
(continued)

I think there were...maybe three kinds of people.

People that initially went [and] just said 'This isn't for me—I can't go anymore.' I think those people probably dealt with that pretty soon and it's probably not an issue for them anymore. There were people that were at the other extreme, where they were there tireless hours and days and months...I think they [also] came to terms with it early.

And I think there's another type of person...who got into the sort of psychosis of it and, you know, did what they had to do at the time, and then sort of stepped back from it, and maybe thought they were okay at the time, and then later looked back and said, 'How the hell did I do that?' That's, I think, that's the category I fall into...

For some of us we're able to, to turn off the emotion. Desensitize and get the work done, and that was an ability that not everyone had, even if someone thought that they were the toughest person and they could do that work. Some people could and some people couldn't...it simply is what it is.

You detach. You dehumanize. You do the work and then you return and you reflect on it, and sometimes it takes a lot to draw out what those emotions were at the time, and to get in touch with them, and some people never do. They just dehumanize, come back and forget about it.

And once rehumanization is allowed to take place, then you're vulnerable again. You desensitize yourself and then you're okay and when you, when you accept that you have senses and you tune into them again, then you're vulnerable...

Usually, when I'm very intense about something, I'll write something down effortlessly...But you know, the funny thing was, that in the very early going, I couldn't write anything down.

"You detach.

 You dehumanize.

 You do the work..."

It was only after a few weeks that I started to write, and when I started to write...that's when I realized what actually happened. The reason why I couldn't write at the time is because I wasn't in touch with emotion. I wasn't in touch.

Three weeks later is when I started to get down into it, and I wrote quite a bit about it. And I think—as a matter of fact I'm sure—that that was the major part of my rehumanization.

I think that the reality part of it will stay with me, and how, you know, how intensely real all that was...the rawness of what I was doing there and how...I don't know. Just how naked and unrefined the whole thing was. I think that...it's almost like there are no rules at that point. There's no order. It's chaotic.

I mean you're really seeing, getting that extreme sense of...you're really seeing that yes, human life is precious. How fragile the human body is, but more, how fragile the human spirit is...I mean people died, but the spirit of everybody surviving died a thousand more times...

The truth is that you die. When something like that happens—there is evil and there's innocence. That's it...No matter what situation, those things always seem to be there...and time. Because time is everything.

I mean people told me their story about 'I was late to the Trade Center that day because my train was late' etc. Well, they're telling me that story because they were late. If they weren't they wouldn't be telling their story.

I pride myself on being late all the time."

Eunice Kang

age 30,
with cell phone

Eunice is very close to her cousin, Christine, who worked in building 2.

"I thought, 'Holy shit, Christine's down there.' I tried to call her at work, but couldn't get through. I started crying and classmates tried to calm me down. It was incredibly upsetting trying to get through...Her mom, my aunt, fainted.

She was on the 65th floor. When [building] 1 got hit, her boss, who'd been there in '93, had them leave immediately. She was in the stairwell on the 10th floor when her building was hit, but she got out. She's a lucky girl.

The worse part was not knowing. After that, I understood why people posted up flyers all over the city...It gives you something to do when you're waiting. I mean, I was ready to go downtown and try to find her. It was totally irrational.

I thought working at OCME would help people find out what happened."

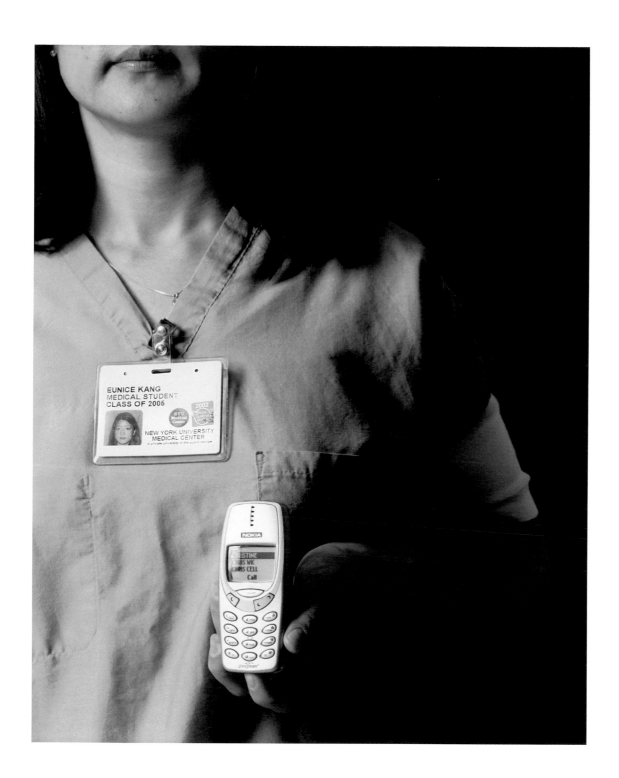

Matthew Goldstein

age 23,
with
photograph
of Gus

What led to you volunteering?

…we had just finished Anatomy and, in a way, we were better prepared to help them identify [remains]. So we were asked to volunteer if we could, to be medical scribes, so I signed up and I kept signing up and I just basically went down there as often as I could handle without either emotionally or academically kind of just failing.

Describe to me the work that you did.

They had these huge refrigerator trucks that they kind of stored all these things in because at the beginning it was so backed up. I mean it was just—it was more to go through than was humanly possible in that amount of time, even with that many people working that many extra hours…I really remember distinctly everyone kind of standing in the street in line and them stopping traffic and the ambulances rolling up First Avenue with police and sirens going and everyone stopping what they're doing, just to show some kind of respect and dignity for the people that were being brought in.

Then once the, once the…I don't even know what to call them—the body parts. Once the whatever it was was brought in, we would help sort through it and do our best to identify what the bone fragments were—basically just identifying it so that when the ME's actually looked at it, we could let them know 'this is I think this'…then they would go through and do a much more thorough examination and identification of it and most importantly, really take samples of things that could be sequenced for identification…

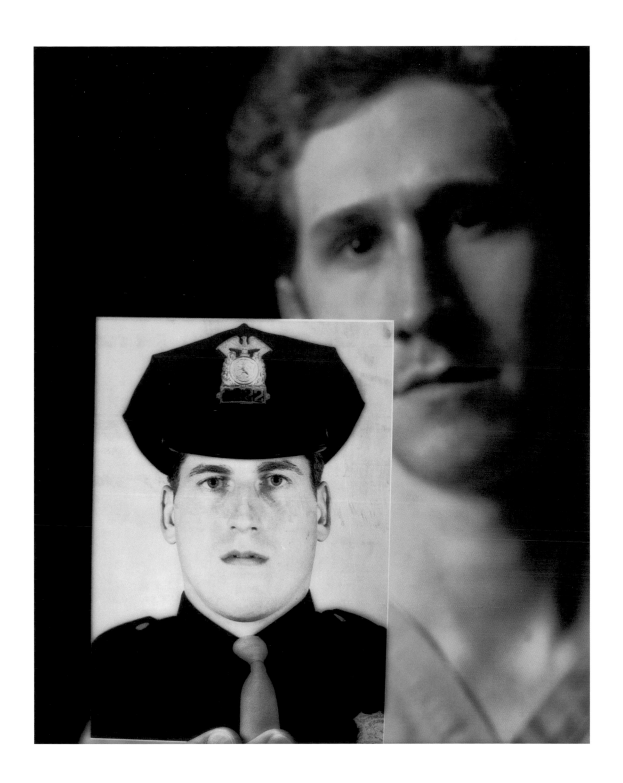

Matthew Goldstein

(continued)

What do you remember the most about this experience?

The smell. [pauses] I mean it was indescribable. It was an amazing thing in the sense that it was like nothing I had ever smelled before, but it's not something that if you smelled it anyone would have to explain to you what it was.

I would say that and...what I said before about people lining up and–you know I don't think I've ever saluted anything in my entire life. I mean maybe I put my hand over my heart when I was younger to salute the flag in that sense, but standing at attention as an ambulance comes by and police or firemen are bringing home the dead–it was a pretty singularly powerful experience.

How do you think this work may have changed you?

I think I knew coming in that medicine was a hard field. You know people always say that a field like oncology is so difficult because you lose so many patients. The truth of the matter is, I kind of knew walking in that medicine is inherently a losing battle. You know that the best physicians in the world eventually lose 100% of their patients.

It's just...I had had family members pass away, but in all my experiences I don't think I had ever been as close to death on such a scale as I was during that. And strangely enough, it really made me more positive and more confident that I had made the right decision to come to medicine than I think anything else could have ever done.

Tell me about your prop.

For a very long time we'd had a very close family friend to us. Actually a couple–Gus and Judy DeFlorio. And I always knew that Gus was a detective. He'd come up with the police force...I was not really aware of what his role was. I just knew him as my family friend Gus...

"Medicine is inherently a losing battle. The best physicians in the world eventually lose 100% of their patients."

But I'd grown really close to him and he—I cared a lot about him and he cared a lot about me and around September 11th I think everyone's world kind of shrunk down and kind of everyone developed tunnel vision for an extended period of time. And I think I was dealing with the volunteering that we talked about and medical school and all those things and unknown to me at the same time he was deeply involved in the investigation side of September 11th.

And again, I didn't know this at the time, but the FBI decided to work really closely with the NYPD and the local police departments …and so it turns out Gus was one of the major people that they turned to to help with the investigation…they had to make this warehouse, this horrible broken-down warehouse into a kind of a worksite for the investigation, and he worked there nonstop for a number of months. And then about a month and a half later, Gus started to really feel sick in a lot of different ways. He just felt worn down and he kind of attributed it to the work and the amount of stress and the number of hours that he was working—Gus is kind of a man's man…he never ever went to the doctor, because I think for him that would have been the sign of weakness…

And so eventually I think around December he went to a physician because he was really still feeling sick and…he was diagnosed with very late stage lung cancer…and he just became really sick rather quickly and passed away very early in May of the same year, right as medical school was ending for me.

…before Gus passed away…he had been telling my father about the work he was doing, or as much as he could tell him, and I guess my father was telling him about the work that I was doing…And I think he just was incredibly touched and most importantly, proud of the work that I was doing…

And the [photo] is of him when he was much younger…when he was I think a rookie in the police force…I think I like that picture most just because it reminds me of—I'm sure he was about the same age that I am now.

Haydee Brown

age 24,
with friend and
OCME volunteer
Michelle Mendoza

Haydee Brown was not interviewed until 2004, when she was work-ing as a first year resident in Orthopedics.

Tell me about your background.

I started [dancing] when I was three or four. At first I was at Ballet Hispanaco and then I moved over to Alvin Ailey. I would leave school five minutes early, run over to Ailey, dance for 4-1/2 hours and then come back and do my homework. I think that discipline is what has carried me through to where I am at now, definitely. I went to Wellesley and did Latin American studies. I [figured that] I would do science for the rest of my life and I had always been interested in Latin American politics, Latin Ameri-can history. I'm both Afro-latino and African American. I'm named after Haydee Santamaria who is a historical figure in the Cuban Revolution.

I came to medicine through my career as a dancer. I always knew I would be some type of doctor. I first planned on being an OB/GYN, just because of the Cosby show, but also [because] I think Roe vs. Wade is very much a challenge, and my plan was to be an OB/GYN...But I became injured while dancing at Alvin Ailey, and I was treated by an orthopedic surgeon with a specialty in dance and sports medicine. From there I just decided to do orthopedics and that was when I was 15 or 16 years old, and it has been that way ever since.

How did you come to do the 9-11 volunteer work?

I had come back from the gym and I got a call from my mom and she said, "Look at the TV, there's been some horrible acci-dent. Someone's crashed into the World Trade Center." I turned it on and of course it looked at that time like it may have been some type of accident, and then you see the second plane hit the building. I think then the second building fell and then I just

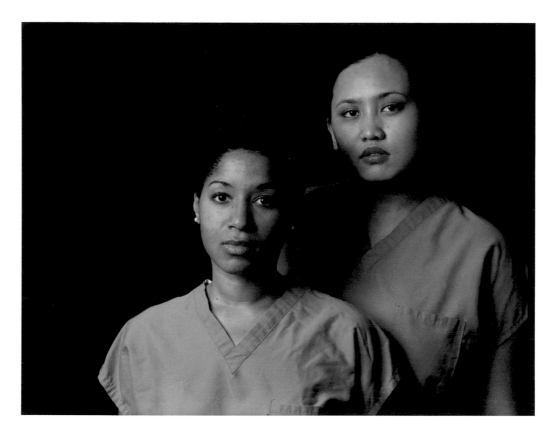

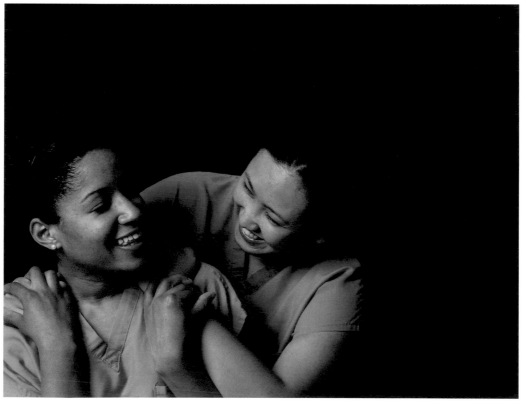

Haydee Brown

(continued)

said, "Well, I can't sit here in this house anymore. I'm going crazy." I couldn't believe what I was watching and I walked over to Bellevue. Not that my year and a little bit under my belt in medical school would have helped in any way, but I had worked a summer in orthopedics and joint diseases, and so they let me set up all these splints and things, but just like everyone probably has already said, no one really came to the Emergency Room. Either people were dead or they walked away from 9-11.

[Later that evening] walking home, I was walking up the street and I saw this [woman], she had like spiked hair and crazy red lipstick, a female medical examiner trying to pull these body bags off of a truck, just a regular white truck, and I asked her, "Do you need any help?" She was like, "Yeah, I need help," and it was just her and me and the person unloading the truck, so I started to help out. I asked her if there was anything else that I could do and she said, "You know, a lot of body bags are coming. If you can just open up the bags and help separate what's coming in or if you see the bones or if you can just separate it. We can't assume that everything coming in one bag is the same person..." and so I stayed there until 11:00 or 12:00 at night. We were busy. Most of them were body bags. Some parts came in Brooks Brothers bags because apparently they ran out of body bags and they were sending things in the Brooks Brothers suit bags, which to this day I don't think I want a Brooks Brothers suit, just be-cause it reminds me of opening the bag or seeing through the little window like...you are not really sure.

So I basically functioned as a triage person. The bags would come in and I would open the bag and we would sort it out and then put them in these little plastic bags and then the plastic bags would be sent further down. There were triage people, two of those, and then there were four stations which later, I think, be-

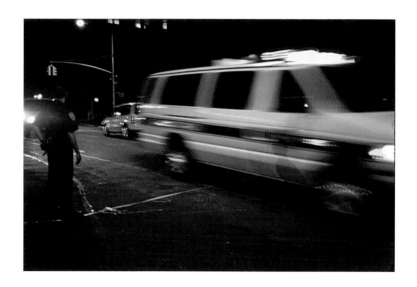

came six stations, and at those stations they would go through it and get the DNA...

...and the FBI immediately came and...we were supposed to sort through any papers...to identify if there were any papers with Arabic or a language we didn't understand and we had to hand that over to the FBI. I mean, it was the World Trade Center that collapsed, so there were tons of papers...

And I was just there. I was more or less a zombie. I was there maybe 16 hours a day. I stayed there for about three weeks. I wasn't going to class. I felt like this work was more important– when I would go home and watch TV, I would want to immediately go back to the Medical Examiner's office.

Sometimes we would get entire bodies. I remember one person, one girl who looked, I mean she looked like she could have been one of my Wellesley classmates, and so many Wellesley people go to

Haydee Brown
(continued)

Wall Street. I mean it's different now, the economy, but when I graduated from college investment banks were knocking on your door trying to get you to work there and giving people very large signing bonuses, and this woman just looked like she could have been a classmate of mine. She was Asian and she had like a Banana Republic suit on. I just remember because we had to undress her and she looked so well preserved. She looked as if she was sleeping. So that was an easy identification. But then we would get like a hand in the next bag or a bag full of different hands...

Hands were a little hard but...since I was just at the beginning of my second year, I could think of it as anatomy, and they told us to think of it as, "You know, it's like anatomy class, you're sorting through this, you can identify that bone, we can send that there," like it's just a very methodical process. But then every once in a while when you would get these entire beings, or maybe just...a leg with a tattoo on the ankle of a rose, and you just [recall that] these are people. These are people and, although it's good for me to, you know, objectify it, because it helps with the work, they are people. I think that the hard part of leaving, and seeing the [memorial] walls, was that these things, these parts, were people, and on the walk home you are reminded who they are.

I remember maybe the second day the woman, the ME that was there, she stopped coming because so many firemen were coming in, or police officers, and her father and her brother, I think, were both firemen, and it was people that she knew, and she just could not do the processing for them because she would often come out crying, understandably. It was really overwhelming. The first couple of days, like the trucks, entire trucks filled with bags...

Why I think I really kept going was there was a community there. Between the corrections officers and the police officers and the Fire Investigation Bureau...like we were all kind of

"Why I really kept going was there was a community there...like we were all mourning and dealing with 9-11 together."

mourning and dealing with 9-11 together and we were seeing–I don't think that many people, not that many people saw what happened. I mean you saw the buildings fall but you saw people walk away. You heard of people being dead, but we were actually seeing the remains and knowing these people...

The hardest part of walking home from the Medical Examiner's office was that all of First Avenue was plastered with these signs of family members or people looking for people, or people would come up to the barricade and ask if we saw their family member and give us a picture. I was just very overwhelmed by that...just the outpouring of New Yorkers.

I think that helped me feel that I was contributing, and I thought the work was extremely important, because you have hundreds, or really thousands of people who are looking for their family members or their loved ones, and the only thing that will give them closure is the identification of these remains. And it was, yeah, I felt that it was very important work.

What do you remember most about your experience?

I remember...this fireman. His name was Martin Rivera.★ I remember when his bag came through. His face was well preserved but then the rest of his body was burned. I mean he had all his gear on. It had his name on it. He had tattoos. And he looked, again, he looked like he was sleeping. I remember that night when I got home CNN had a story on him. I was just like, "Oh my God I can't escape this guy." I mean even talking about him now...and he occasionally would appear in my dreams and I think that is ultimately why I stopped going because...because I couldn't sleep at night and he kept being in my dreams and then–why, when I am walking down the street, was his picture

★ *pseudonym*

Haydee Brown

(continued)

the one that I would notice on the wall? Just that, because he kept popping up in my real life, not just in my dreams, that I knew it was definitely affecting me.

It's now three years later. Have you and he come to a reconciliation?
Yeah, I mean he is definitely not in my dreams, but then [recently] I walked down the street, and whose firehouse do I walk by but his firehouse, and it had his picture up and it talked about 9-11. I remember for a certain period of time after 9-11, every day I would go by the firehouse and leave flowers or something, the firehouse right up the street from here. I would leave flowers there just kind of as respect to them and what they did and then like seeing what I had seen and knowing what they had gone through. So it like just did a flash. I didn't really think about 9-11 that much. I talked about it every once in a while but he, this one fireman in particular, it just all came back to me at that moment in time and I was a little taken aback by it.

How did the rest of the year go for you?
It was a challenging year. I think I didn't get all of the 9-11 stuff past me and, like we would talk about 9-11 in class or something and I would get upset...

So I think that I was able to funnel all my anger from seeing all these body parts into, "Why did we make ourselves vulnerable enough for this to occur and what is wrong with our policies?" And, of course, that wasn't the mainstream view in the country. Everyone was like, "Yes America, God Bless America, we're so fabulous." I mean my politics are very different than that, and I kept a lot of that inside because I was working with FBI, corrections officers, cops. I'm not going to say any of those things and there were the rumblings of the Patriot Act and everything else toward that time and I just felt that it wasn't going to be acceptable. It still isn't, really.

"I definitely have a respect for death and how people view death. I think it has changed me..."

...but I think that 9-11 could have been a wake-up call to say, "Okay, so clearly our foreign policy doesn't work. We need to reevaluate." I mean...it was an occasion where the whole world had sympathy towards the United States and it could have been used as an opportunity to really kind of change our policies, and we had enough international backing to do that and still be the most powerful nation in the world, but to be more compassionate and more humane.

...but then everything fell apart...I mean, our country is the way our country is, but it's a little frustrating. It's definitely frustrating. So we can all just do our little part by, whatever, me by being a doctor or whomever …

Did your attitude towards death change?

I always saw death as very removed...Like I didn't really deal with death at all. After 9-11...dealing with remains...it's not the same as anatomy lab where these people donated their entire being, blah, blah, blah, for the love of science. It was people going to work that day, on the wrong day, in the wrong place, at the wrong time, and that just made it much more personal...

I had a patient die two weeks ago in the ER who was an alcoholic, and he died of a GI bleed secondary to liver cirrhosis and, you know, his whole lifestyle basically led to his death. I just view death so differently that once he died...I took time to wash all the parts of his body that would be exposed to the family, and I wrapped him in a sheet very carefully. I felt that that was very special for the family to see him in the best state that he could be in for them to really grieve...I guess I would have been that caring in the past but I'm not sure. I maybe would have just rushed on to the next thing, but I think that I definitely have a respect for death and how people view death. I think it has changed me to the benefit of my patient care and the way I deal with death in my family and of loved ones.

Haydee Brown

(continued)

Tell me about your "prop" – volunteer Michelle Mendoza.

I think that we really just have that special bond from being there...

We were always there way past when everyone else was there. I think that we would see each other in the hallways here in the medical center and just look at each other and it was like, "I understand what you are going through, but our work is important." I think that she was my support during that time. I don't really speak to her or anything now. I mean if I'm here in the medical center I would say "hi" but we're not good friends, but we shared this really special bond during that period of time.

It was really crazy, that space–it was all that death, but we would, like, go and get candy and joke...and I think that since we experienced that together we were supporting one another. Like I would call her and say, "Michelle, you know this freaking Martin Rivera, he's still here. He's still chasing me. He's still in my dreams" and she would say, "Well, you know, I have my own being, these remains...and it will go away. Some of it may stick with you, but it won't be as emotional for you." She was amazing. I hope I did the same for her.

I think that...I think the last night I was there it was Michelle, [another student] and myself, and we were just sitting on the curb, and there were no bodies coming in and we all three of us just started hysterically crying out of the blue. And that was the first time that we had cried in the office, the office being 30th Street outside. It was like a release, I guess. You would [go from] eight hours without trucks coming to there being trucks back to back to back. At that point in time it was like, "All right, I can't be here anymore. This is too much." I don't know, it was just like we were sitting there and...there was a passageway and people wrote poems on the wall, and you would have the hearses com-

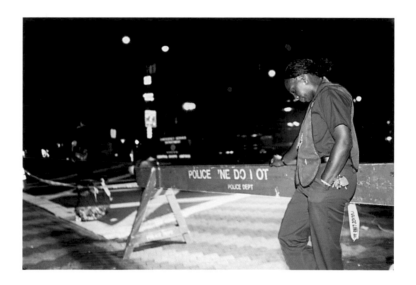

ing out, and I think one of the, yeah exactly—now I remember. We'd just finished saluting the remains of whomever, fireman or policeman, and they left and we starting reading the poetry on the wall and one of the poems was something about people's souls going up in the air and the burning of the buildings. It was just too much and we just sat down on the curb and just became really emotional and started crying. I think one of the other workers came by and said, "We're glad that you guys finally cried. You've been here for too long without crying…"

That's when I basically stopped. I would go by every once in a while but they weren't busy anymore. There was maybe one truck a day coming in. They really didn't need much, and I had to be a student again. [Dean] Rey was like, "It's time for you to go to class, Haydee. 9-11 is important but you need to be a doctor."

Myra Finn

age 24,
with rosary,
crucifix and
candle

What did you do?

Scribing, a lot of waiting. We sat at a table, the ME [medical examiner] to the left, FBI and NYPD to the right. We'd record where the remains were found on the grid area. The ME took samples. There was no emotion–very professional.

Toward the end they found a shoe...It was a worker's boot, not a Wall Street type.

What do you remember most?

The smell. You breathe it in and can taste it in the back of your throat.

Describe your props–the candle, crucifix and rosary.

The crucifix is just a Catholic thing. The candle–I'd walk to the church on 33rd and light a candle...it's very beautiful–light in the darkness, that sort of thing. It's ritual; you do it without thinking.

I've had my rosary since my first communion. I'd fall asleep with the rosary in my hand. It's just a comfort–you can't crawl into bed with mom anymore.

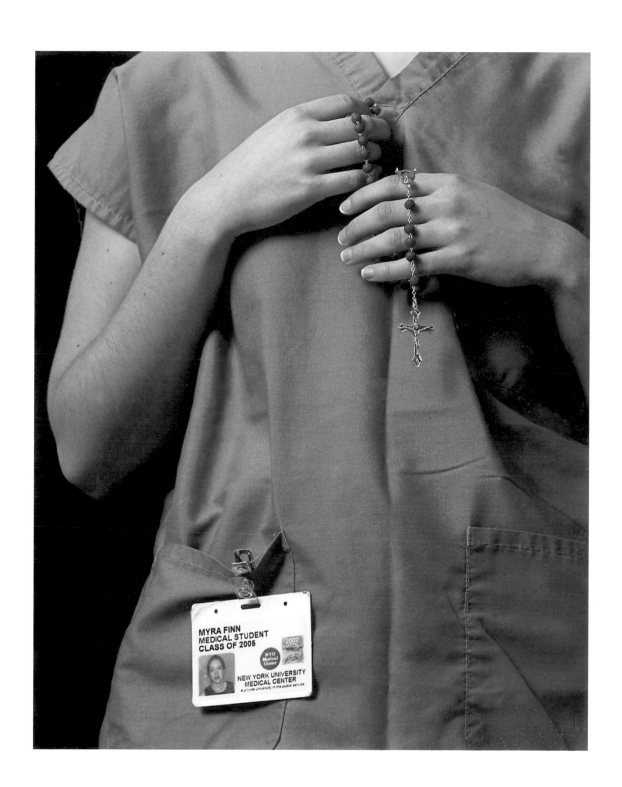

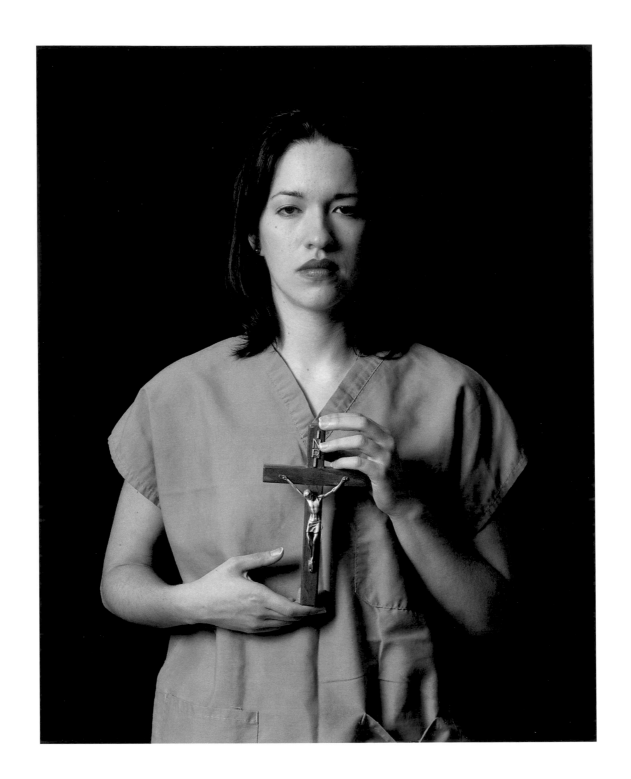

Myra Finn

(continued)

How were you changed by the experience?
> I've lost a lot of faith. What I saw...
> I don't talk to God anymore. I used to, but now I don't.
>
> Religion has always been a comfort. Now I'm very angry.
> Thinking of 9-11, how can you love any Being that allows this
> to happen?
>
> It's strange. I still ask God every day if I can believe in him.

What does he say?
> He hasn't answered yet.

dedicated to the medical students of the class of 2005

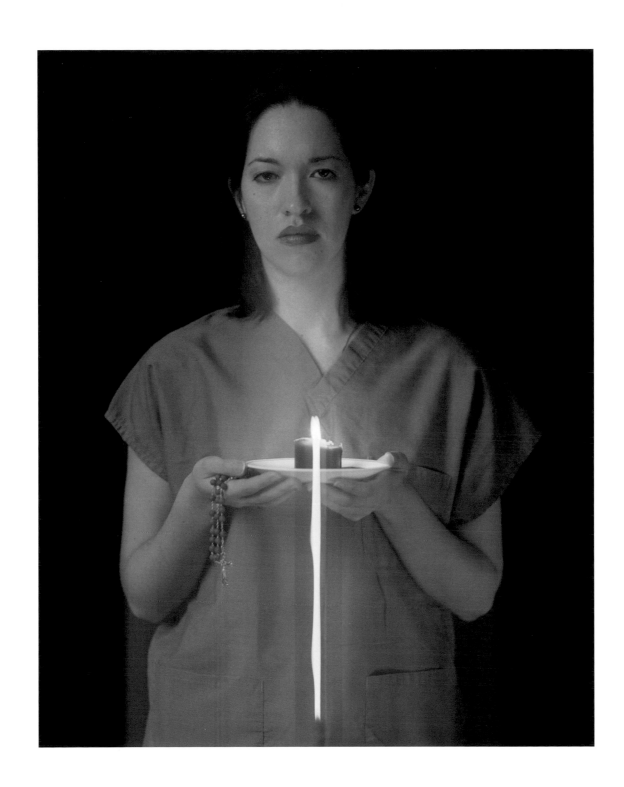

Acknowledgements

A project like this is simply not possible without the support and cooperation of a number of individuals and institutions. Foremost, I'm indebted to the Master Scholars Program of the NYU Medical School, both for providing a home during the trying 2001–2002 academic year, and for its financial support for this book. Drs. Mariano Rey, Steven Abramson, Sharon Krackov and Elissa Kramer welcomed me into the Program, and administrators Corry McKee, Cristy Hebert and Sharon Unterman saw to every need a visitor could ask for. The University of Rochester Medical Center provided sabbatical support to complete the project, and Williams College provided a place to do it. Guenet Abraham brought a sense of mission and immense skill to the book design. None of this would have mattered without my wife, Andrea Barrett. "Support" does not begin to convey her contribution.

Lastly, I am immensely greatful to the students. Although not one of them would say so, allowing the use of their images and voices is an act of courage, and makes this work their own.

Author

Barry M. Goldstein, M.D., Ph.D., is Associate Professor of Medical Humanities at the University of Rochester School of Medicine and Dentistry and Adjunct Professor of Humanism in Medicine at the NYU Medical School.

His photographic work deals with social documentary and medical themes and has been widely exhibited.